THE NEW YORKER

BOOK OF DOG CARTOONS

Also available from Hutchinson
The New Yorker Book of All-New Cat Cartoons

THE NEW YORKER

BOOK OF DOG CARTOONS

HUTCHINSON
LONDON

1 3 5 7 9 10 8 6 4 2

This edition first published in 1998 by
Hutchinson

Random House (UK) Limited
20 Vauxhall Bridge Road, London SW1V 2SA

Random House Australia (Pty) Limited
20 Alfred Street, Milsons Point, Sydney,
New South Wales 2061, Australia

Random House New Zealand Limited
18 Poland Road, Glenfield,
Auckland 10, New Zealand

Random House South Africa (Pty) Ltd
Endulini, 5A Jubilee Road,
Parktown 2193, South Africa

A CiP record for this book is available
from the British Library

Papers used by Random House UK Limited are natural,
recyclable products made form wood grown in sustainable
forests. The manufacturing processes conform to the
environmental regulations of the country of origin.

ISBN 0 091 73460 6

Printed and bound in Great Britain by
Butler and Tanner Ltd, Frome, Somerset

THE NEW YORKER
BOOK OF DOG CARTOONS

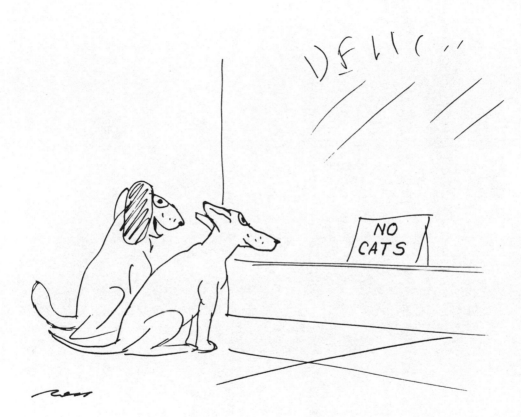

"Hey, the tide has turned!"

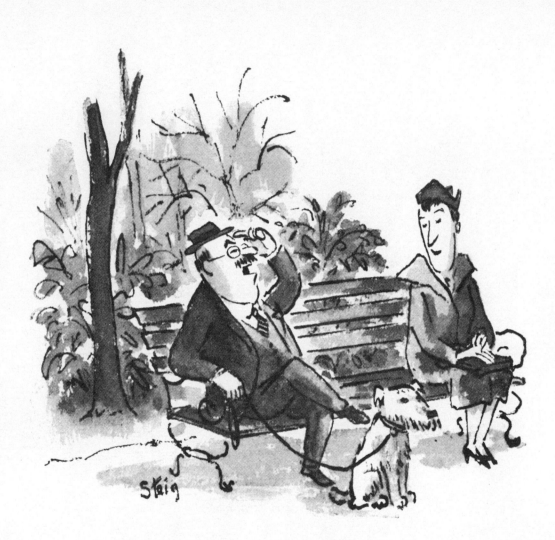

"*Mongrels have it up here.*"

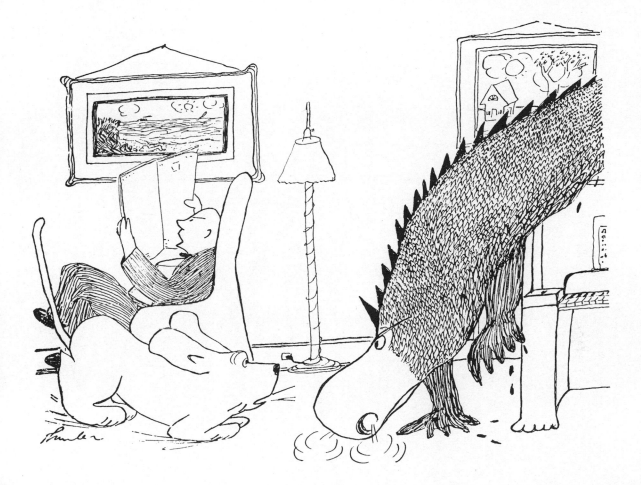

"Shut up, Prince! What's biting you?"

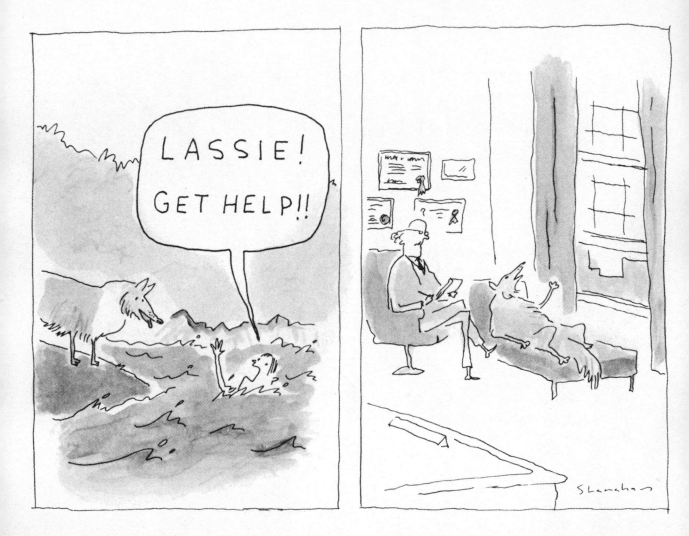

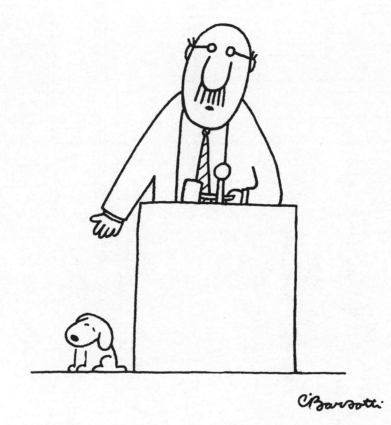

"The bidding will start at eleven million dollars."

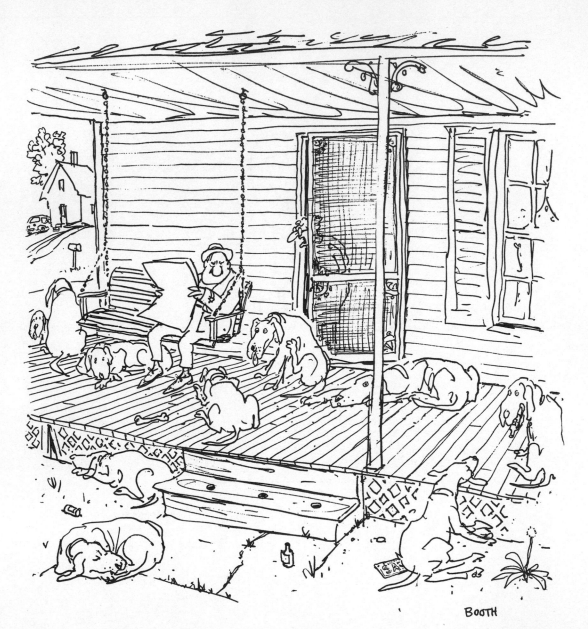

"Did you woof?"

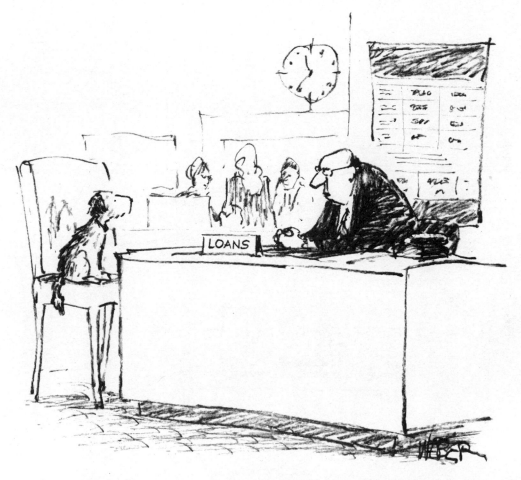

"*If you had an account here, it would be a different story.*"

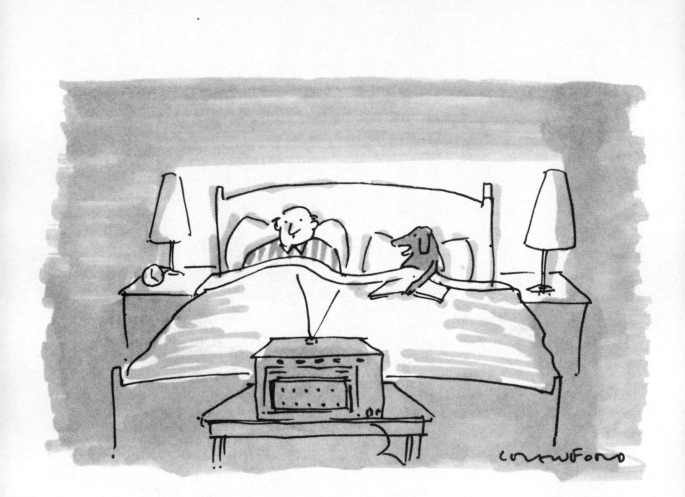

"*Joe, I want out.*"

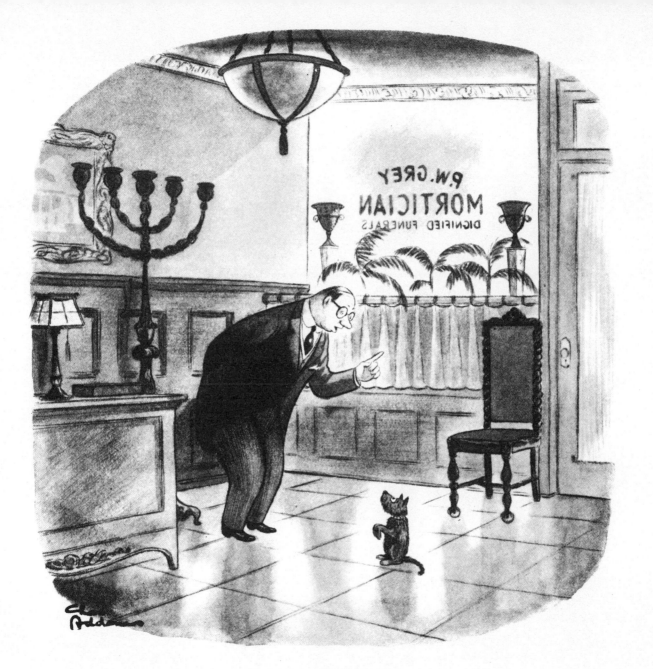

"Now play dead."

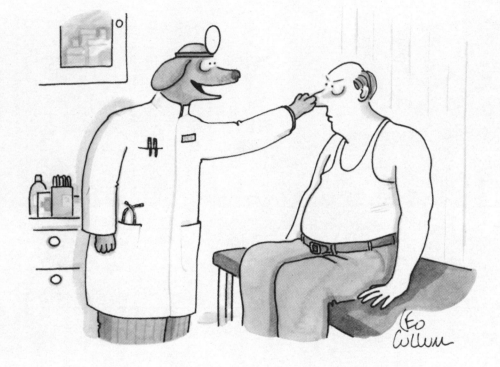

"Well, your nose feels cold."

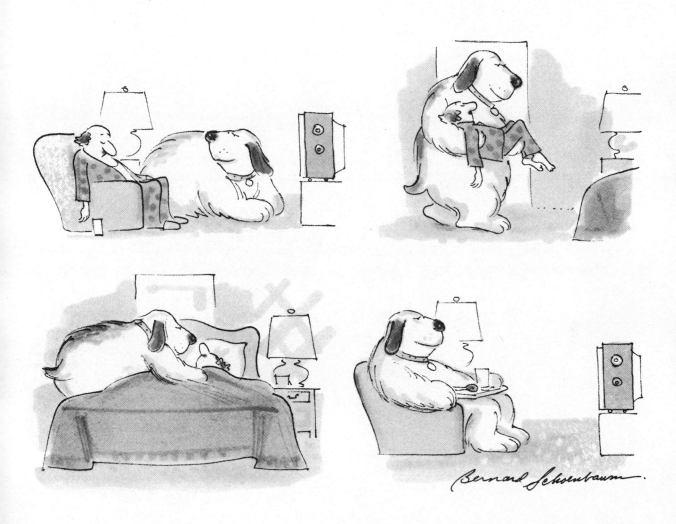

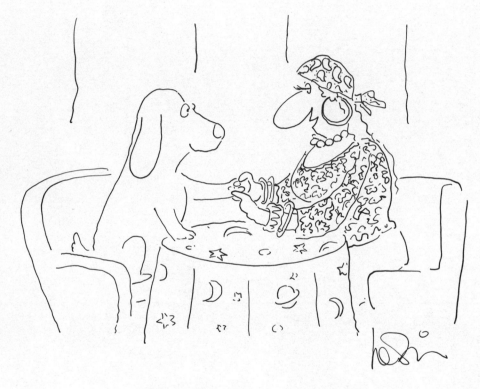

"You will be going on a long walk."

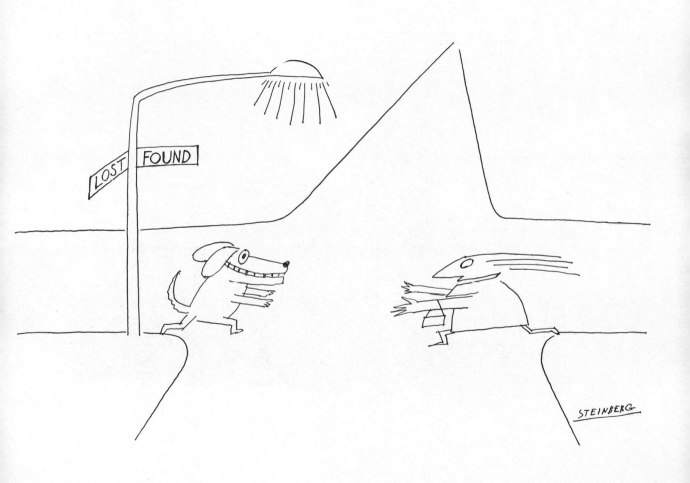

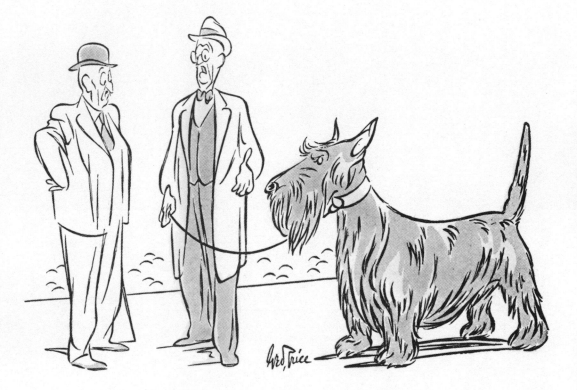

"*We think it's a glandular disturbance.*"

IT'S TIME TO TREAT YOUR DOG TO
Le Bon Chien.

THE FIRST HAMBURGER-FLAVORED LIQUEUR <u>FOR</u> <u>CANINES</u> <u>ONLY</u>!

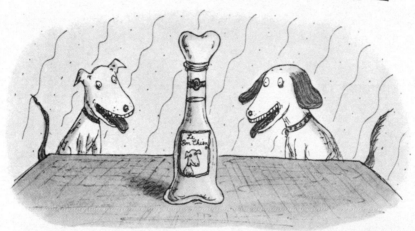

Try serving Le Bon Chien in any of these delightful ways:

"Fido"

Fill bowl with ice cubes. Pour 3 oz. Le Bon Chien over ice. Serve.

"Lassie in Reruns"

Mix 2 cups water with ¼ cup Le Bon Chien in bowl. Serve.

"101 Dalmatians"

Pour 12 oz. club soda into bowl. Add 3 oz. Le Bon Chien. Float slice of bologna on top. Serve.

R.Cht

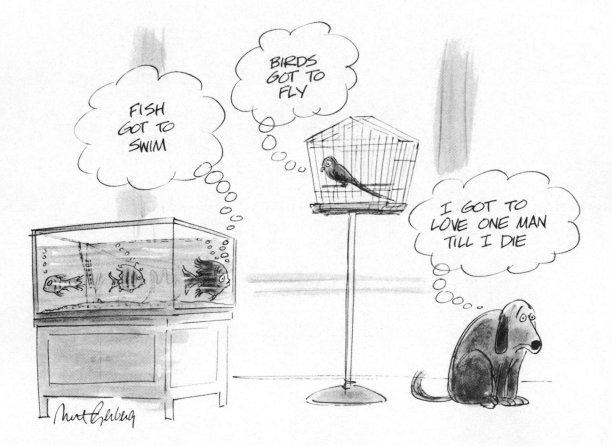

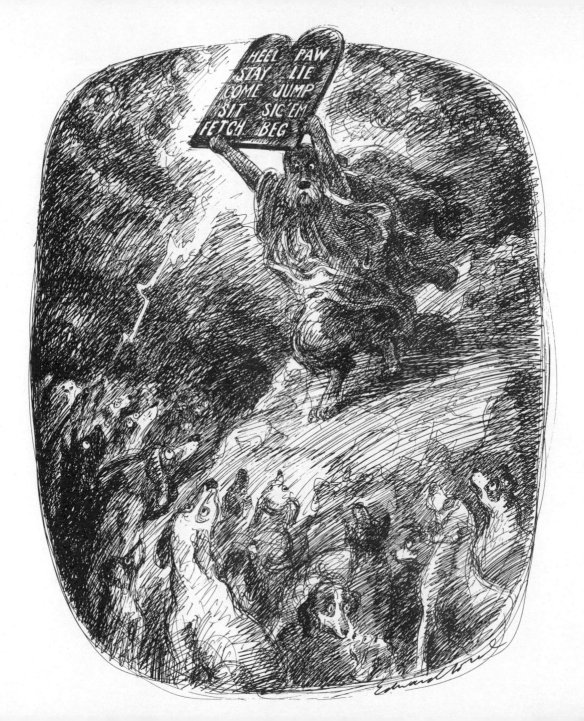

HEEL PAW
STAY LIE
COME JUMP
SIT SIC EM
FETCH BEG

17

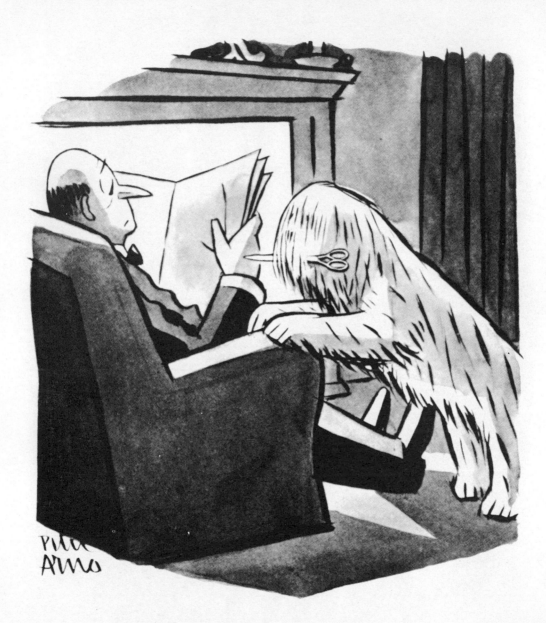

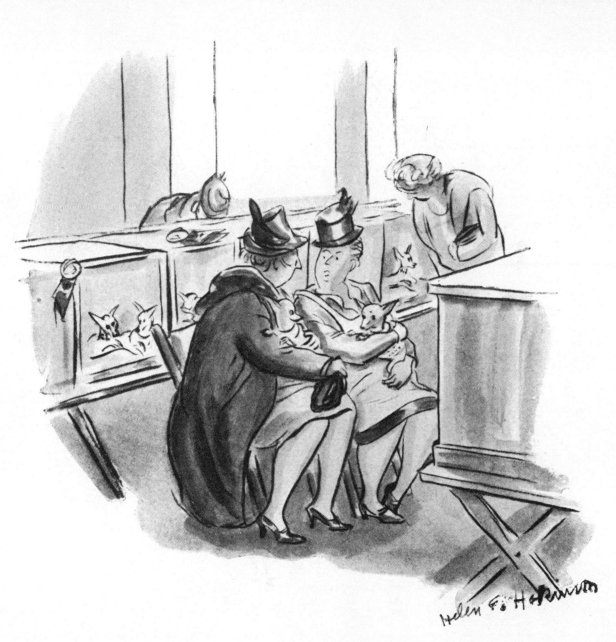

"She's very like her father and has something of his sense of humor."

"Do you want to handle this or should I?"

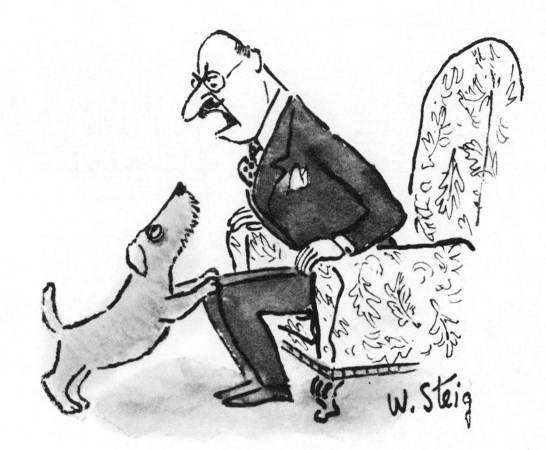

"Stop fawning!"

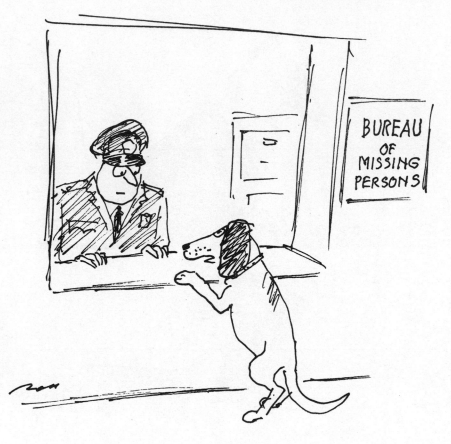

"He's about five feet six, has big brown eyes and curly
blond hair, and answers to the name of Master."

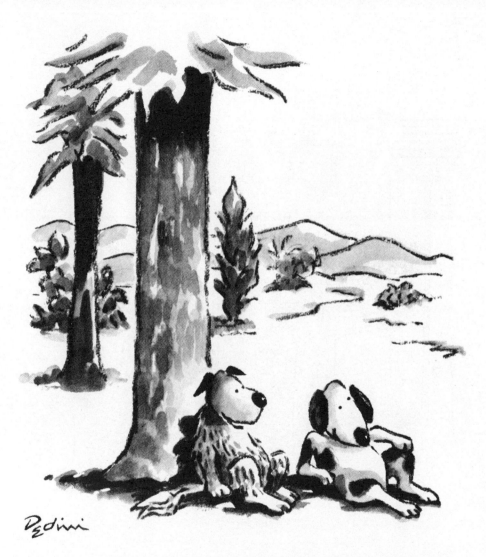

"*We should get out to the country more often.*"

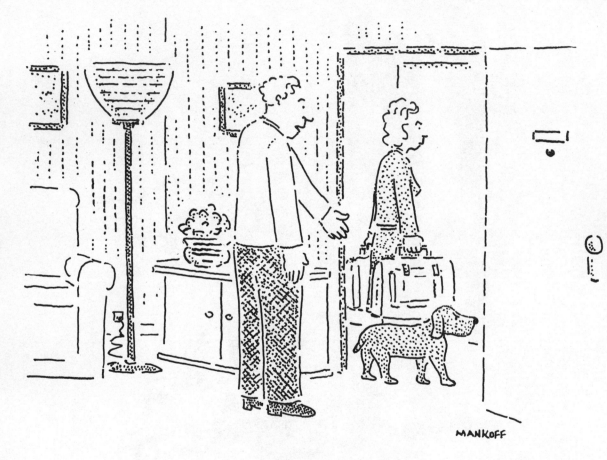

"*Et tu, Baxter?*"

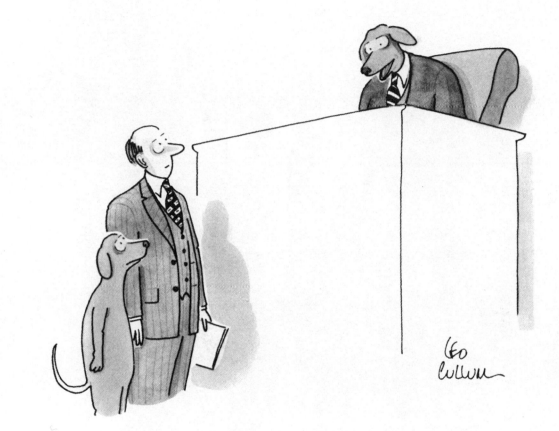

"I'm going to disqualify myself."

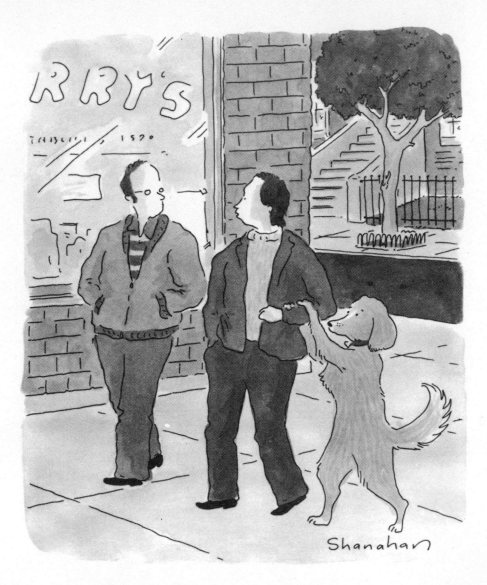

"*She never took to the leash.*"

"Yes, I'm talking to you. I believe you're
the only Sparky in the house."

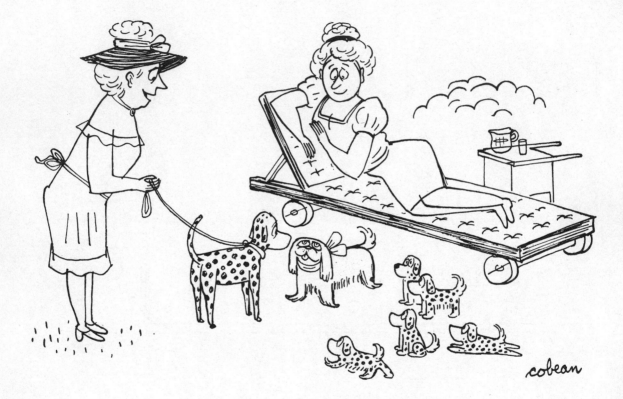

"*You remember Trixie, don't you, Freddie?*"

"They never pushed me. If I wanted to retrieve, shake hands, or
roll over, it was entirely up to me."

30

"*We want to send a hostess present to a dachshund.*"

"*If you lie down with pugs, you wake up with pugs.*"

"Come here a minute, dear. Skeeter's learned a new trick."

"And <u>this</u>, I presume, is Fluffy?"

"I understand that in your country this thing is done quite differently."

"I didn't realize, Your Honor. I assumed the law here was the same as in New Jersey. As you may know, dog eat dog is permissible there."

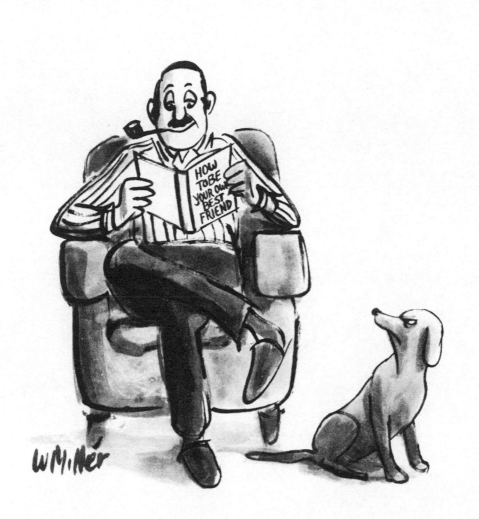

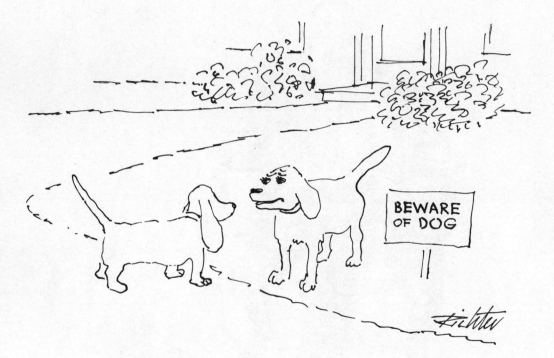

"It's very gratifying, but there's a lot of responsibility
that goes along with it."

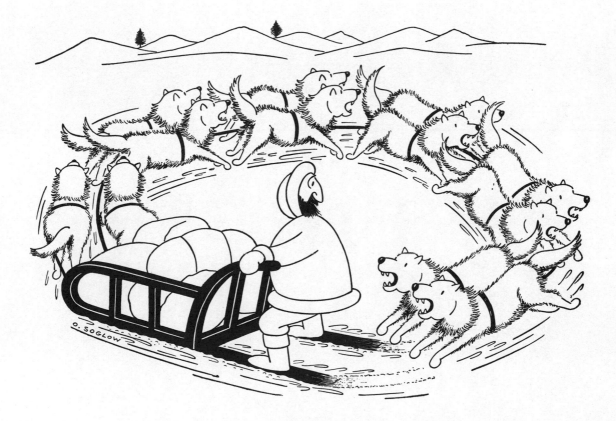

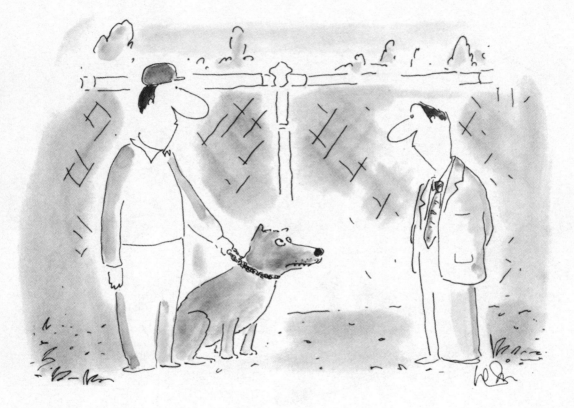

"He's been trained in guard duty, attack, and litigation."

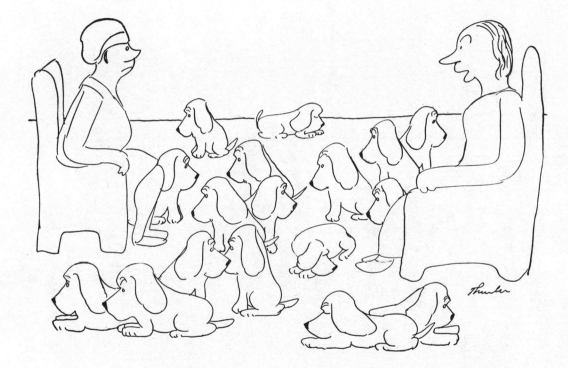

"The father belonged to some people who were
driving through in a Packard."

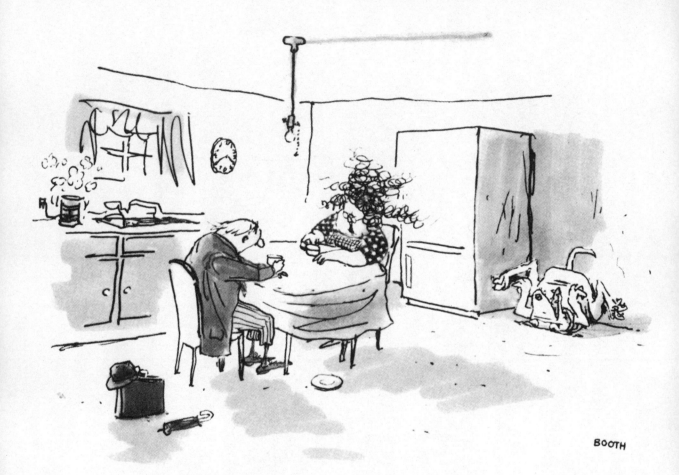

"*Don't give the dog any more coffee.*"

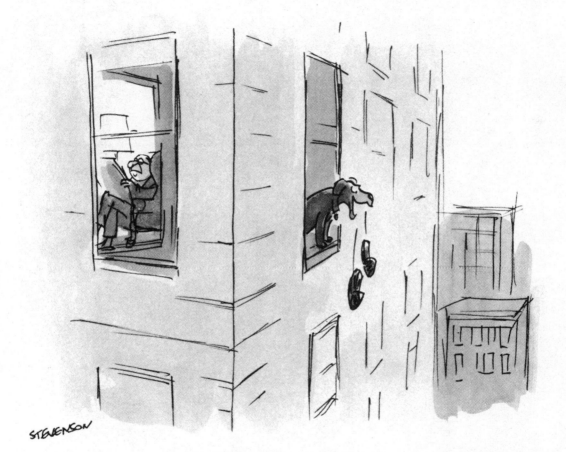

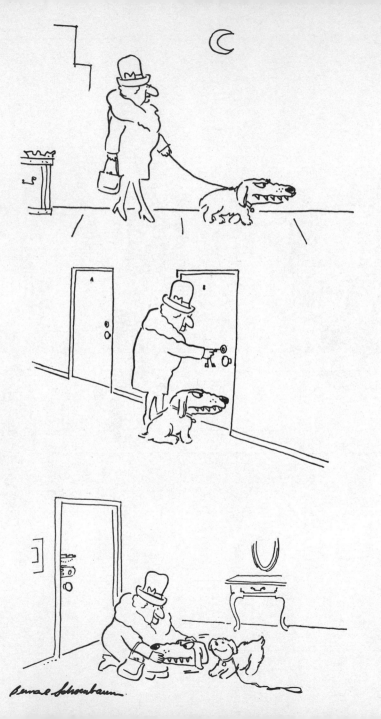

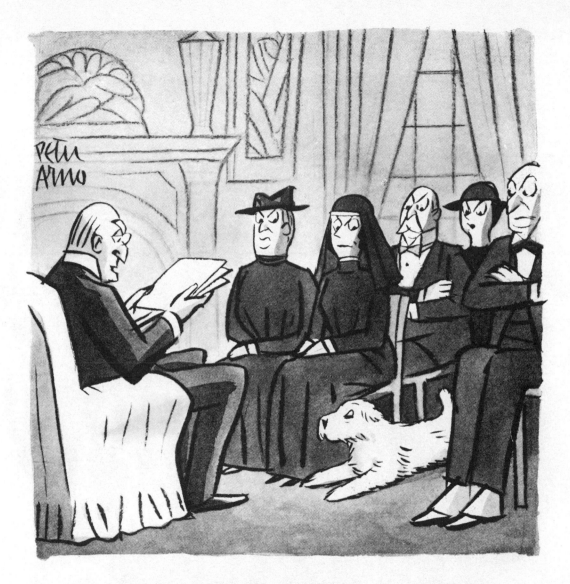

"First then: the bulk of my estate, excepting certain specific bequests as hereinafter noted, I leave to my true friend and companion, one of God's noblest creatures ..."

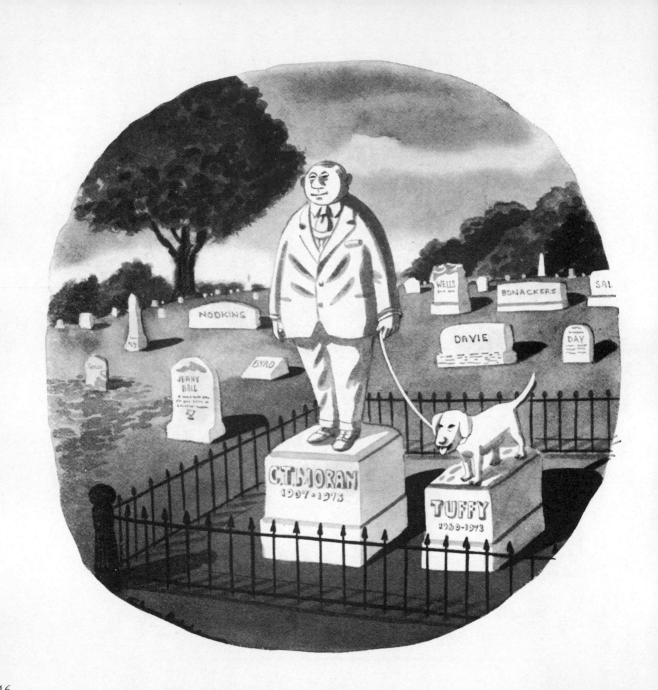

STEINBERG

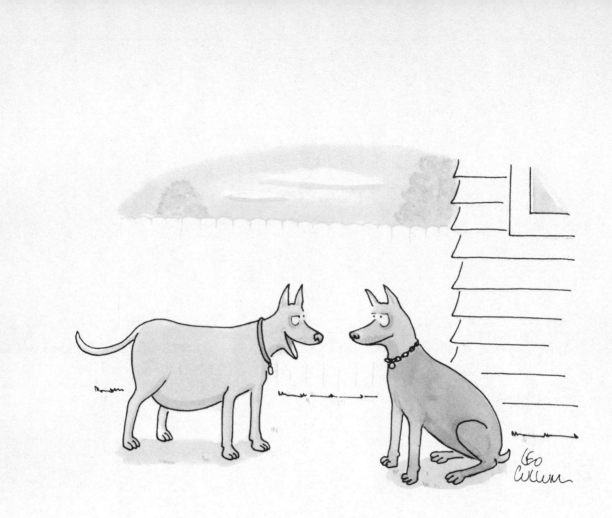

If it's girls, Kimberly, Kaitlin, Lauren, Cindy, and Tracy.
If it's boys, Cameron, Christopher, Adam, Jeffrey, and Gregory."

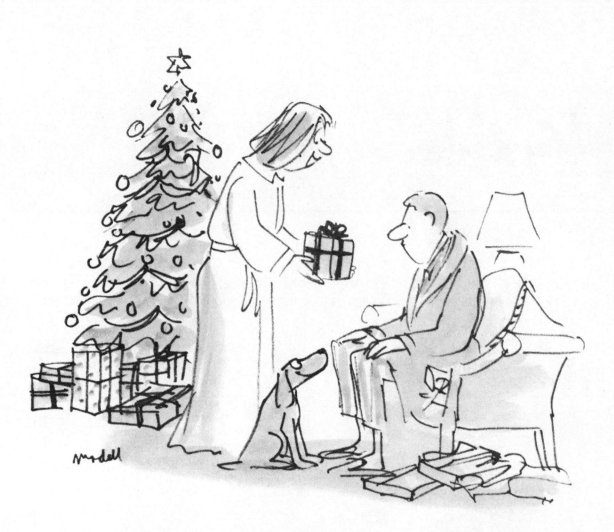

"This one's from you know who, so make a fuss and thank him."

CHILDREN OF CELEBRITY CANINES

BRITTANY:

Daughter of Lassie. Hopes to become an actress/model. Not completely without talent, but close.

LANCE:

Benji's offspring. At the moment, wants to be a rock-and-roll drummer. A borderline socio-pathic ne'er-do-well.

ROVER:

Son of Andalusian Dog. Happy and well adjusted. Nothing at all like his dad.

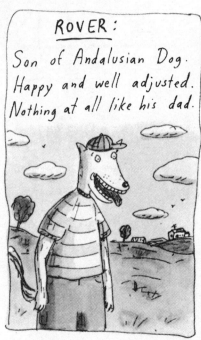

SO WHATCHA LOOKIN' AT, HUH?

R. Chast

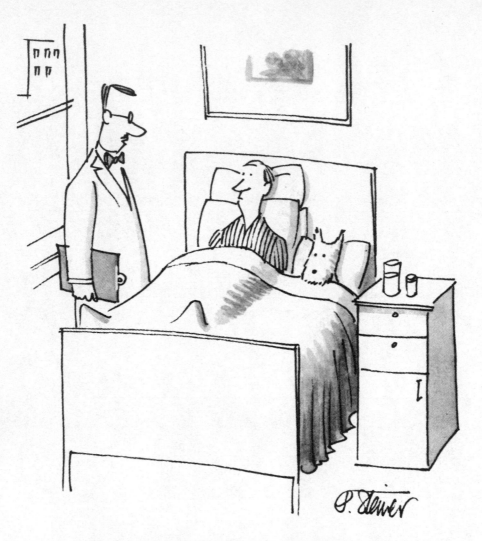

"Under our holistic approach, Mr. Wyndot, we not only treat your symptoms, we also treat your dog."

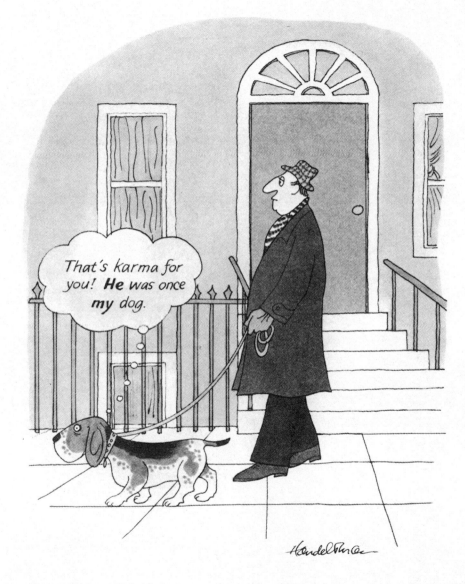

"Well, please look again, Operator. It's Fluffy—
F-L-U-F-F-Y—and she lives in Larchmont."

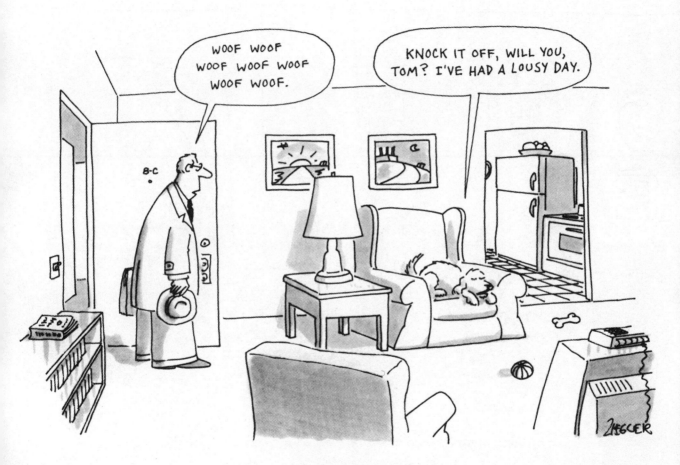

"Once again I find myself in the rather awkward position of having to ask one of you for a biscuit."

"Do you, Daisy, promise to love, honor, and, in particular, obey Mr. Singer?
To beg, sit, stay, heel, and roll over until death do you part?"

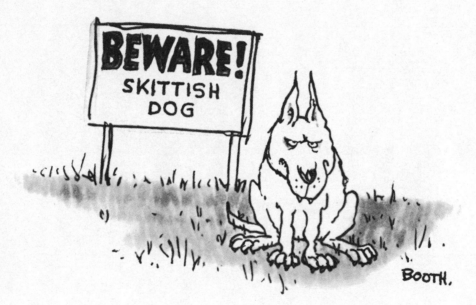

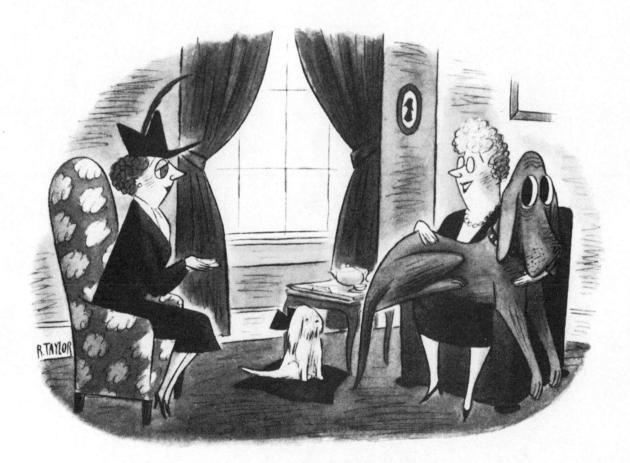

"He's _terribly_ jealous of Fifi."

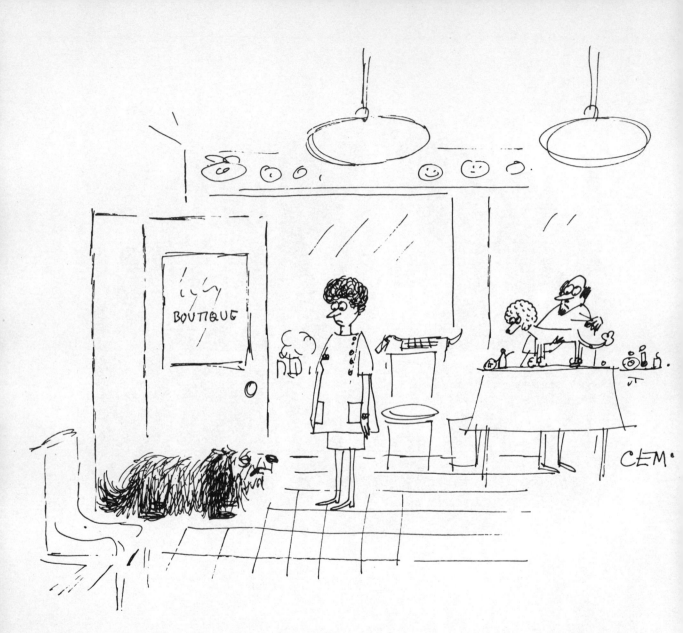

"The works."

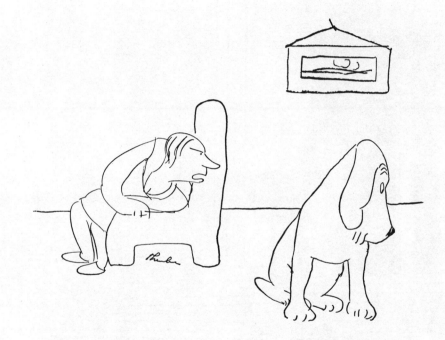

"*You ought to spend more time with your own species.*"

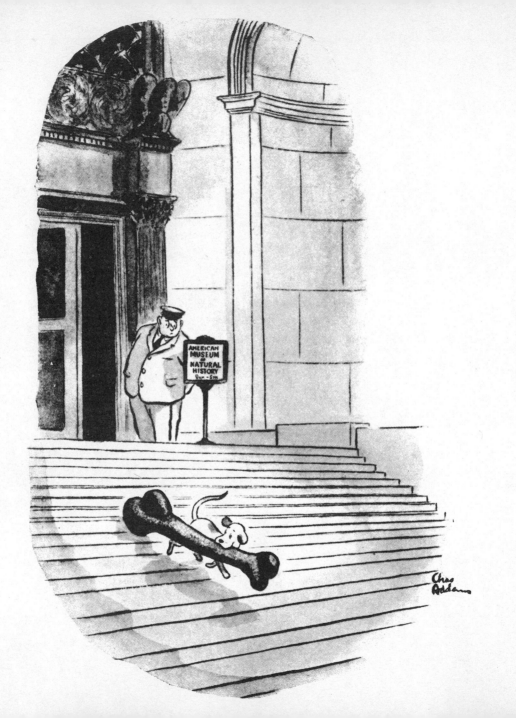

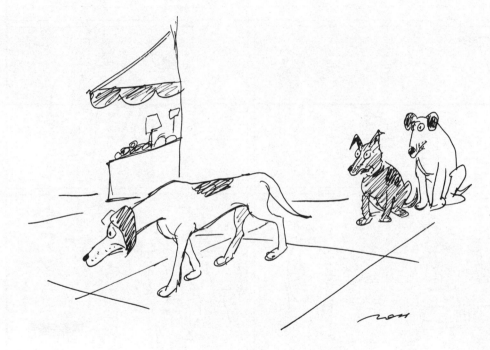

"It's a shame. He's lost the will to fetch."

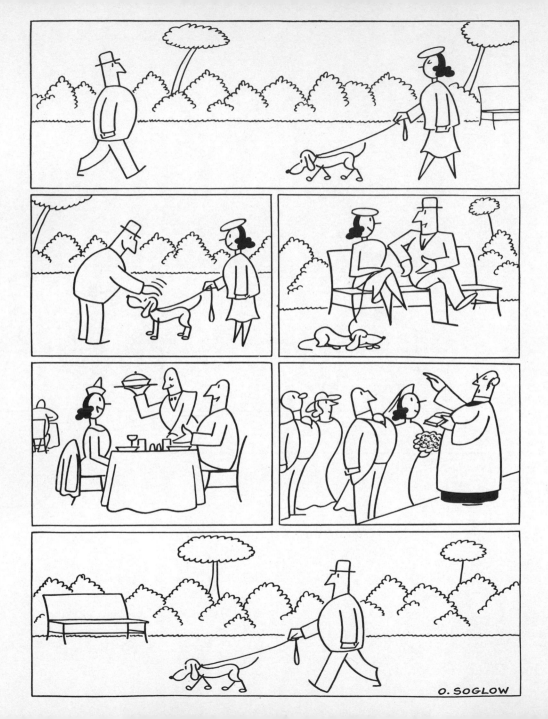

O. SOGLOW

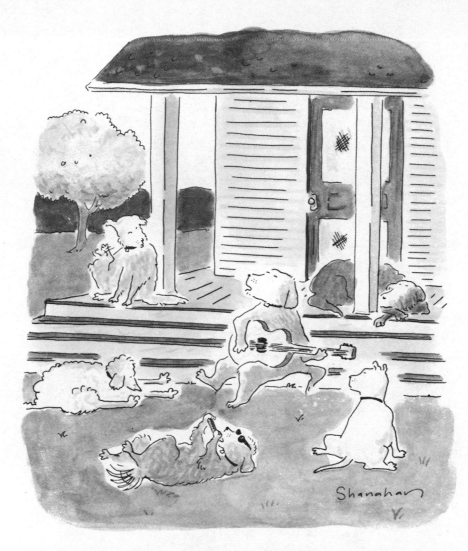

"'I'm a good dog, Mama, I'll bring you your daily news.
I'm a good dog, Mama, I don't chew my master's shoes.
But there's one thing life has learnt me—even good dogs get the blues.'
Blow some sweet harp for me, Lucky."

"He's only four weeks old, and he can already say 'arf.'"

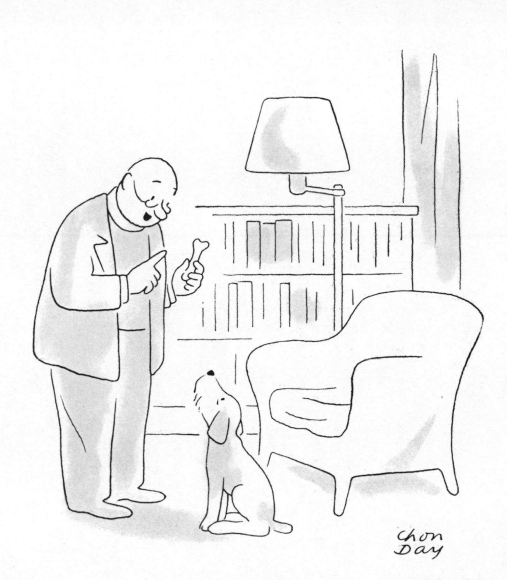

"*Pray for it.*"

THE BLOODHOUND AND THE BUG

1

2

3
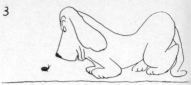

4
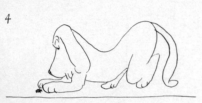

5
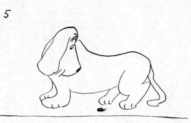

6
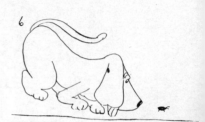

7
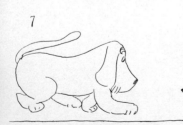

8
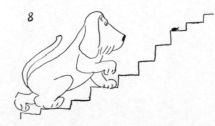

9
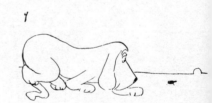

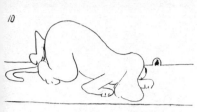

10

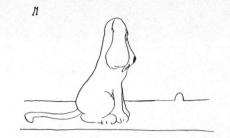

11

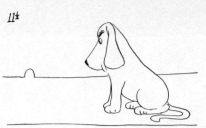

11½

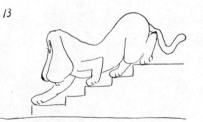

12

13

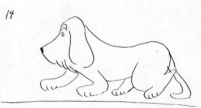

14

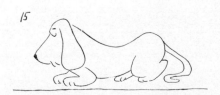

15

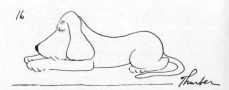

16

Thurber

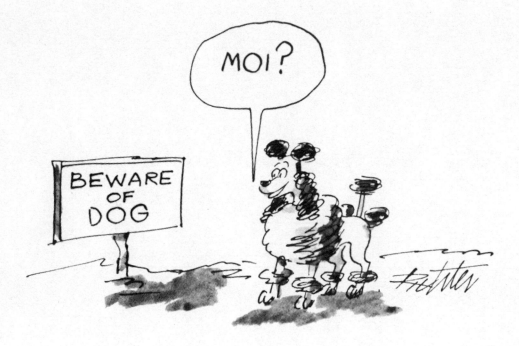

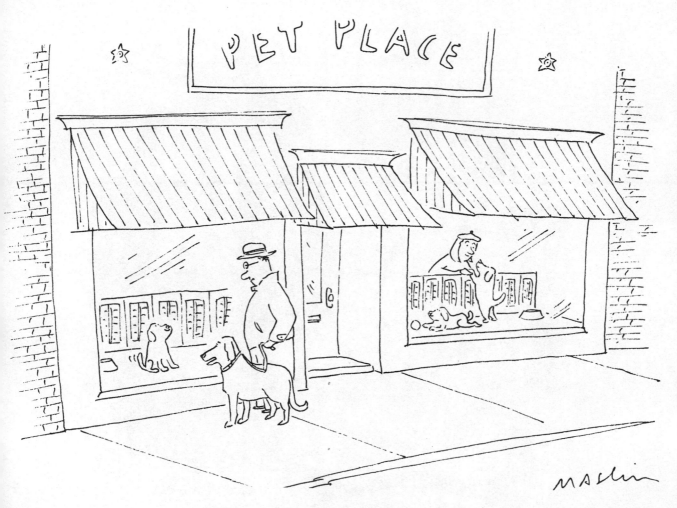

"He _is_ cute, but you already have a dog."

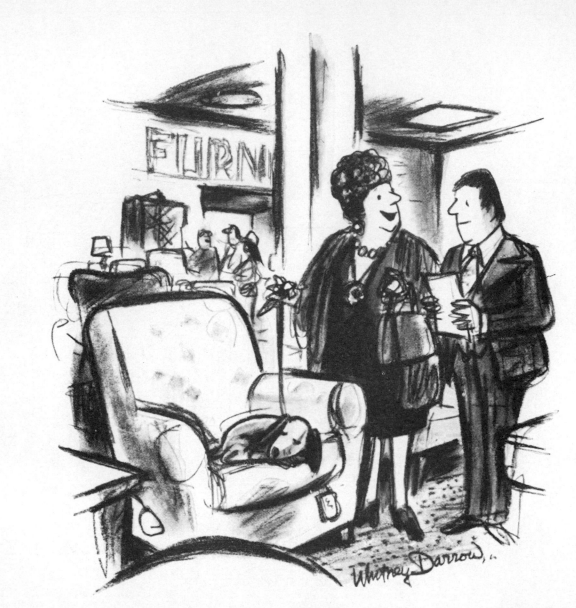

"Sold!"

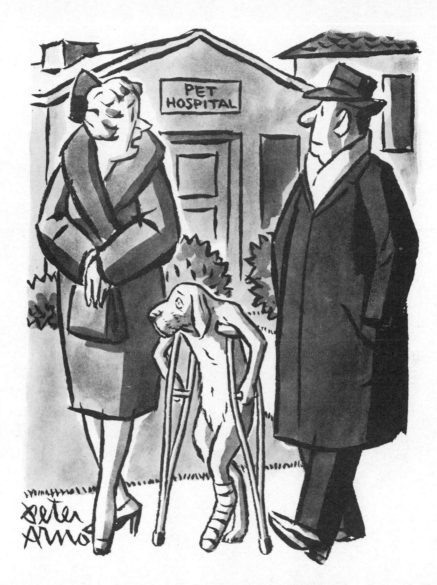

"He may be a fine veterinarian, but we're going to get some funny looks."

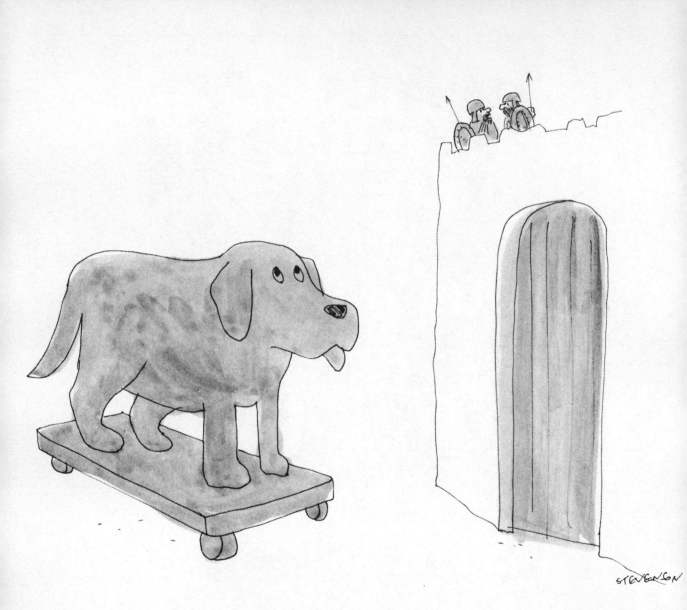

"I think the Greeks are running out of ideas."

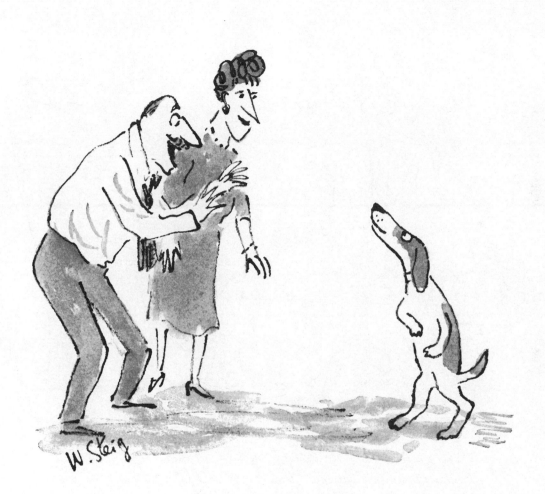

"He's got it! The Frug!"

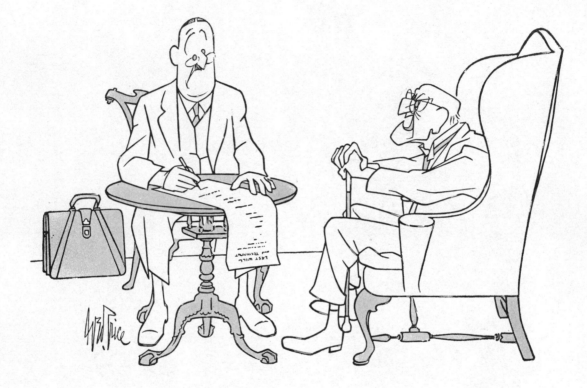

"...and the balance of my estate I want to put into a trust for the care
and maintenance of my most loyal friend and faithful companion, my
dog Spot. Now go out and get me a dog with spots."

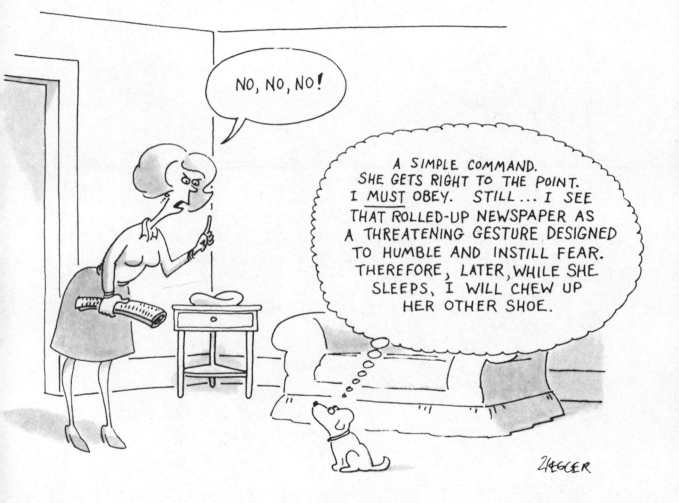

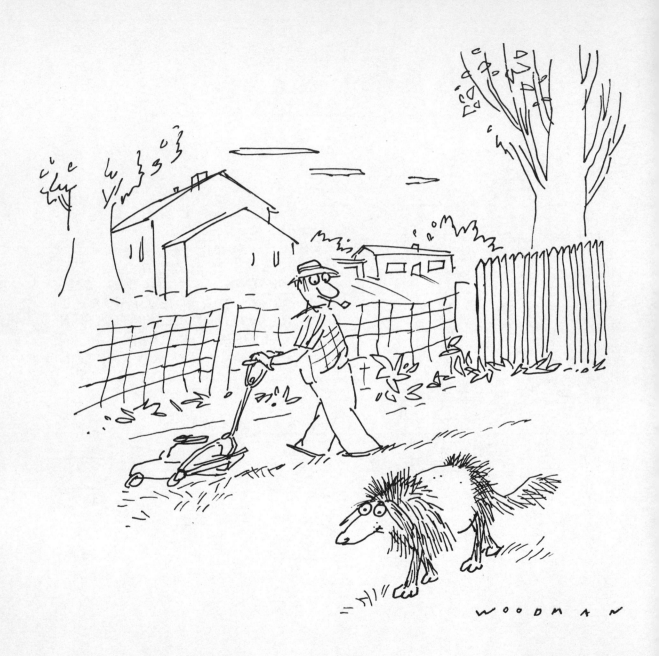

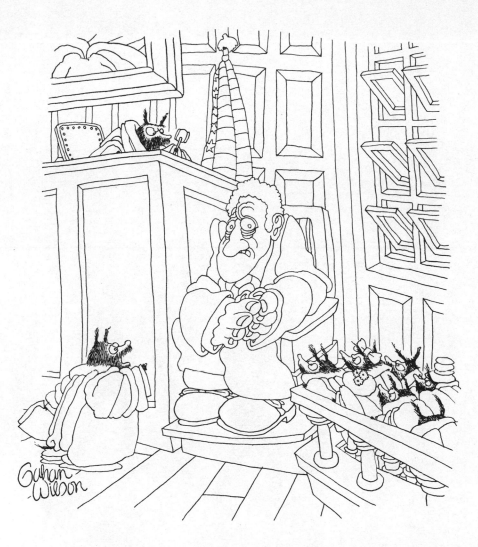

"Did you or did you not employ a leash to drag your cairn terrier, Jack, away from the corner of Park Avenue and Sixty-fifth Street in spite of his making every effort to clearly indicate to you that he wished to stay where he was?"

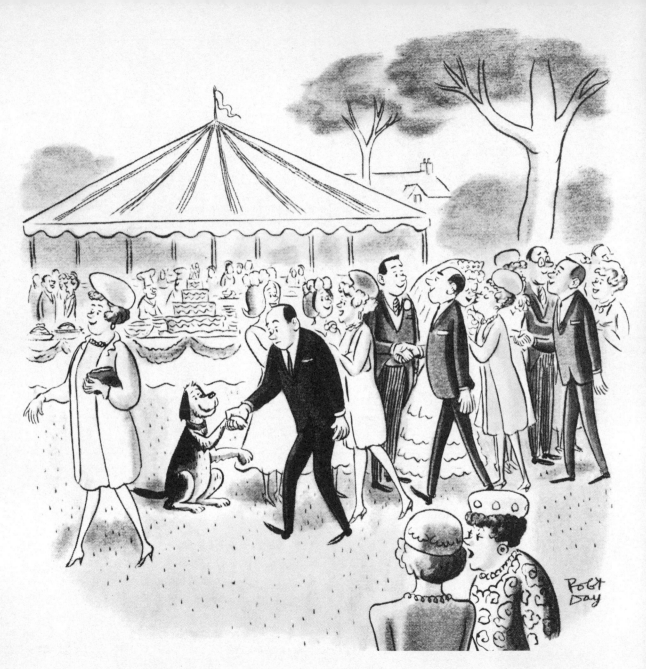

"Well, they consider him a member of the family."

"I'll lay it out for you. We're cutting back, and
we no longer need a dog."

"You've got to get rid of one or the other. It's getting on my nerves."

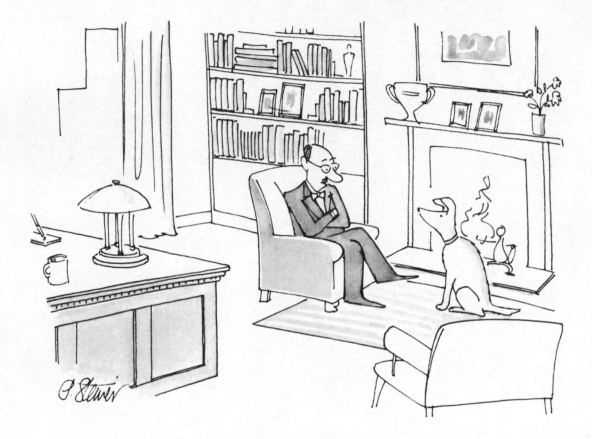

"I've told you why I need a dog. Now suppose you tell me what makes you think you might be that dog."

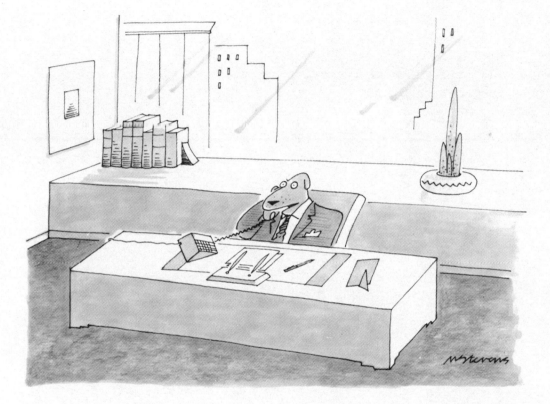

"*Woof woof woof woof!... I mean, get me the Techcorp file, Thompson.*"

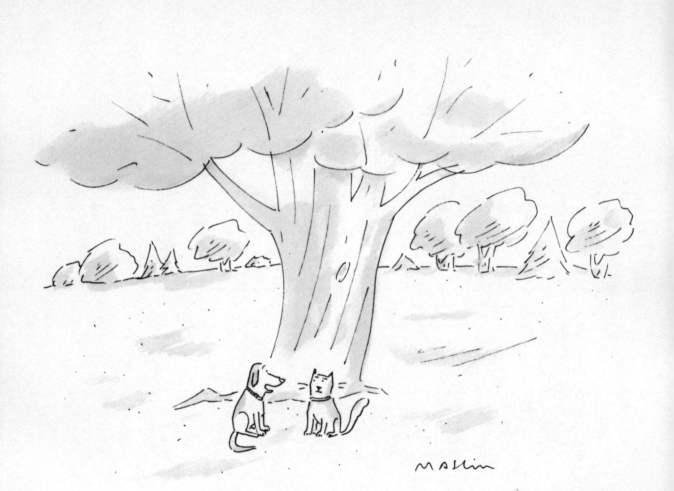

"You realize I'm taking an enormous personal as well as professional risk just being seen with you."

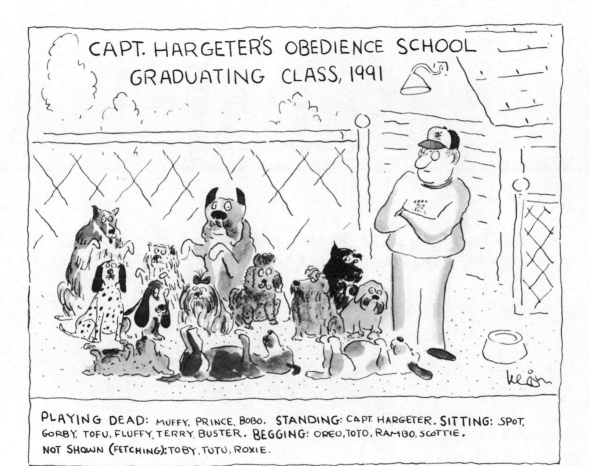

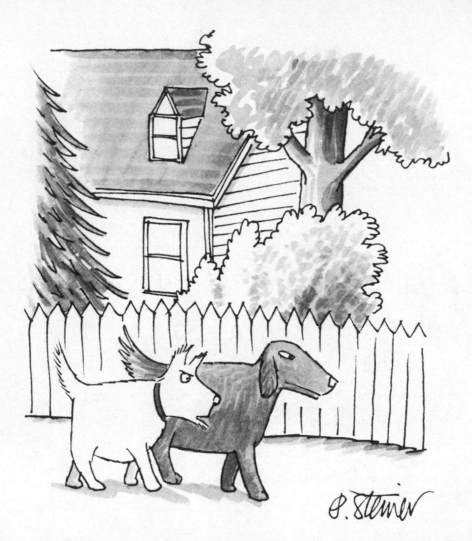

"It's always 'Sit,' 'Stay,' 'Heel'—never 'Think,' 'Innovate,' 'Be yourself.'"

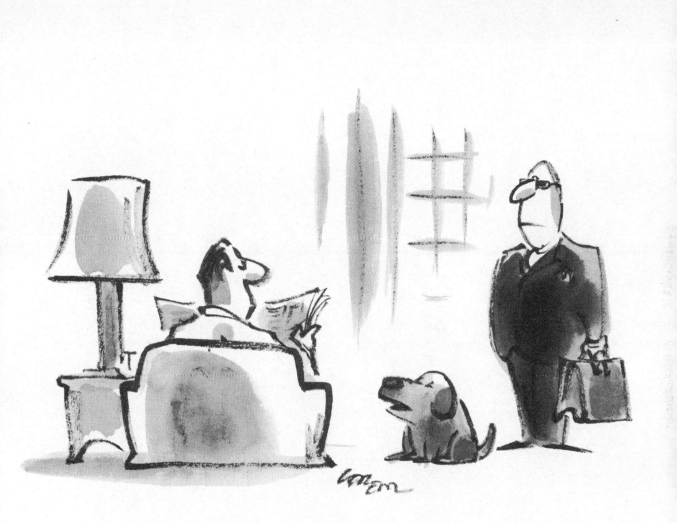

"*From now on, Ted, I will speak only when
adequately represented by counsel.*"

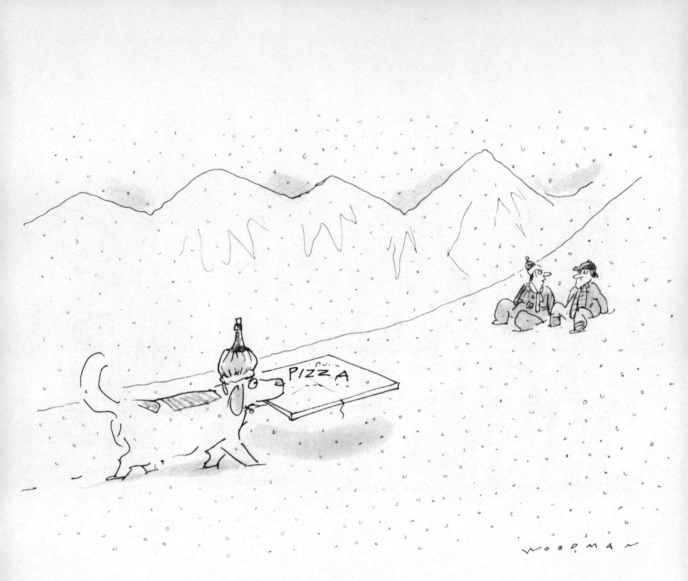

"We must be in the Italian Alps."

"And I'm happy to be here, Johnny."

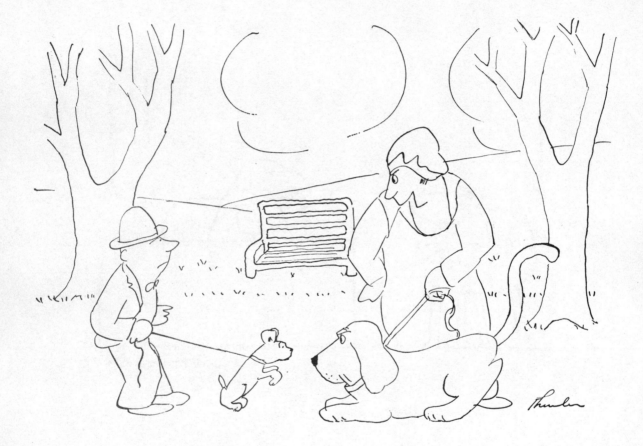

"*Are you two looking for trouble, Mister?*"

"Now, look! It says right here on the can how good this is for you: 'Recommended by veterinarians everywhere. Beef livers appetizingly cooked in their own juices. Vitamin C added. Contains minimum daily requirement of riboflavin . . .' "

"If you two are through with your braised sirloin tips, I'll just go ahead and clear the table."

"The quick brown dog jumps over the lazy fox."

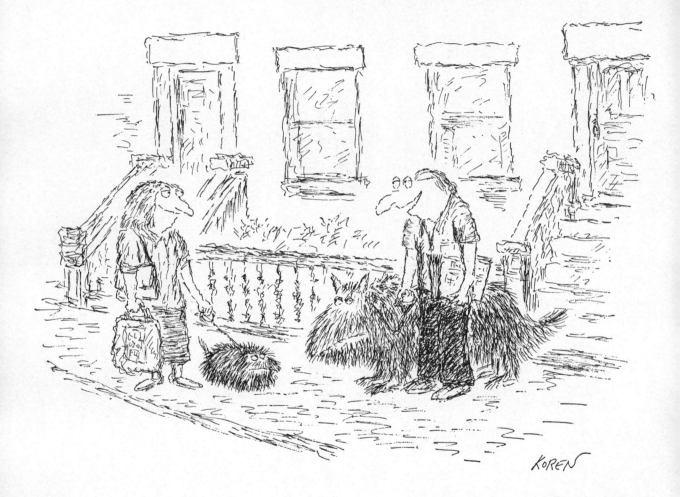

"*How long have you and Charlie been together?*"

"Speak."

"Heel."

"Roll over."

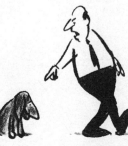

"Stay."

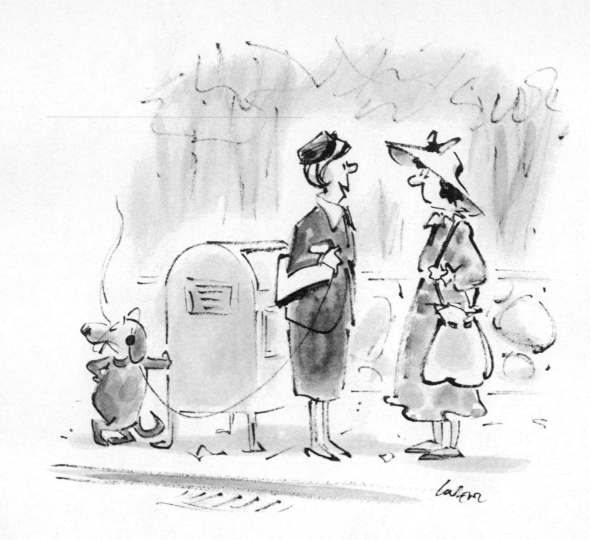

"I used to think it was cruel to keep a dog in the city,
but Homer's made a remarkable adjustment."

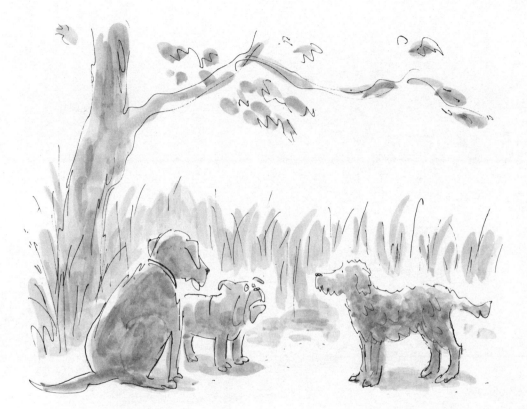

"*Speaking personally, I haven't had my day, and I've never met any dog who has.*"

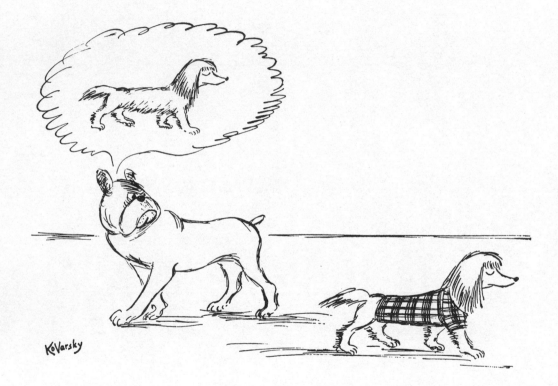

"He has my bite and his father's bark."

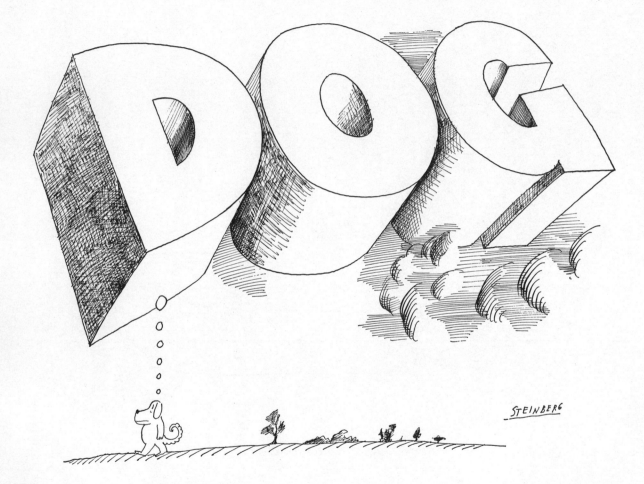

STEINBERG

Index of Artists

The text of this book was set in a postscript version of Caslon Old Face No. 2
on a Macintosh IIci.